Edward Hopper

エドワード・ホッパー

TASCHEN

KÖLN LONDON LOS ANGELES MADRID PARIS TOKYO

EDWARD HOPPER (1882–1967)

Edward Hopper is considered the first significant American painter in twentieth-century art. After decades of patient work, Hopper enjoyed a success and popularity that since the 1950s have continually grown. Living in a secluded country house with his wife Josephine, he depicted the loneliness of big-city people in canvas after canvas. Many of Hopper's pictures represent views of streets and roads, rooftops, abandoned houses, depicted in brilliant light that strangely belies the melancholy mood of the scenes. On the other hand, Hopper's renderings of rocky landscapes in warm brown hues, or his depictions of the sea coast, exude an unusual tranquillity that reveals another, more optimistic side of his character. Hopper's paintings are marked by striking juxtapositions of colour, and by the clear contours with which the figures are demarcated from their surroundings. His extremely precise focus on the theme of modern men and women in both the natural and the man-made environment sometimes lends his pictures a mood of eerie disquiet.

Edward Hopper gilt als der erste bedeutende Amerikaner in der Malerei des 20. Jahrhunderts. Nach zu Beginn nur zögerlichem Erfolg nimmt seine Popularität seit 1950 stetig zu. Hopper, der sehr zurückgezogen mit seiner Frau Josephine lebte, bringt in seinen Bildern die Vereinsamung des modernen Großstadtmenschen zum Ausdruck. In vielen Bildern zeigt Hopper Straßenansichten, Dächer, verlassene Häuser, viele sind von Licht durchflutet und in verhaltene Melancholie getaucht. Versöhnlich stimmen dagegen Hoppers Naturdarstellungen. Felslandschaften in warmen Brauntönen und Darstellungen des Meeres strahlen eine ungewöhnliche Sanftheit aus – und lassen, auf den zweiten Blick, Hoppers Optimismus durchscheinen. Edward Hoppers Bilder bestechen durch ihre Farbkraft. Mit klaren trennenden Linien grenzt Hopper den Menschen von der ihn umgebenden harmonischen Natur ab. Die äußerste Präzision, mit der er den modernen Menschen in seiner Umwelt, vor allem der Architektur, darstellt, bringt bisweilen etwas Unheimliches in seine Bilder.

Edward Hopper est considéré comme le premier grand peintre américain du XXᵉ siècle. Malgré un début de carrière difficile, sa popularité n'a cessé de croître depuis 1950. Hopper, qui mena avec sa femme une vie plutôt solitaire et retirée, a peint des images de la ville où se consume l'intime et infinie solitude de l'homme. Il a aussi peint des rues, souvent dans une vive lumière sculpturale et une mélancolie retenue. Mais la nature telle que la représente Hopper a quelque chose d'apaisant. La mer et les paysages de rochers peints dans de chauds tons de brun expriment une douceur inhabituelle et c'est à travers eux que transparaît l'optimisme de l'artiste. Les œuvres d'Edward Hopper frappent par l'intensité de leurs couleurs. Les êtres humains qu'il met en scène sont isolés de l'harmonieuse nature environnante par les lignes de séparation très nettes. La précision objective avec laquelle il représente l'homme moderne dans son environnement, en particulier architectural, confère à ses tableaux une impression d'étrange stupeur.

Edward Hopper está considerado como el primer gran pintor norteamericano del siglo XX. Poco reconocido al principio, su popularidad creció constantemente a partir de 1950. Retirado a una vida tranquila con su mujer Josephine, sus cuadros expresan la soledad del hombre moderno en el medio urbano. En muchos de sus cuadros, Hopper muestra calles de la ciudad, tejados, casas abandonadas, inmersas en una suave melancolía. Sus cuadros de paisajes, por el contrario, ponen una nota de calma y optimismo. Los cálidos tonos marrones con que reproduce el mar y los paisajes de rocas experimentan una dulzura fuera de lo común y transparentan el optimismo de Hopper. Los cuadros de Edward Hopper cautivan por su fuerza cromática. Los protagonistas de sus obras están segregados de la armónica naturaleza que les rodea mediante líneas claras y precisas. La extrema precisión con que pinta al hombre moderno en su entorno, en una composición caracterizada por los fuertes contrastes de luz y sombra, producen un cierto efecto siniestro y amenazador.

エドワード・ホッパーは、20世紀美術において要となる初のアメリカ人画家である。数十年にもわたる辛抱強い活動の後、ホッパーは1950年代より成功と人気を手に入れた。妻のジョセフィンと共に人里離れた田舎の別荘に住みながら、彼は大都市に暮らす人々の孤独を次から次へとカンヴァスに描き続けた。ホッパーの作品の多くは、その場のメランコリーな雰囲気を奇妙にも裏切る明るい光が、大通り、道、屋根、空き家の情景を浮き出している。一方、暖かい茶色の色調で描かれた岩だらけの地形や、海岸の描写が尋常ではない静寂を見せ、彼のキャラクターのより楽天的な一面を表す。ホッパーの絵画は色彩の驚くべき並置と、人物を周囲の環境から仕切る明確な輪郭によって特徴づけられる。自然や人工的な環境に置かれた近代的な男女というテーマに対する彼の正確な目は、時として作品に不気味な不穏を与える。

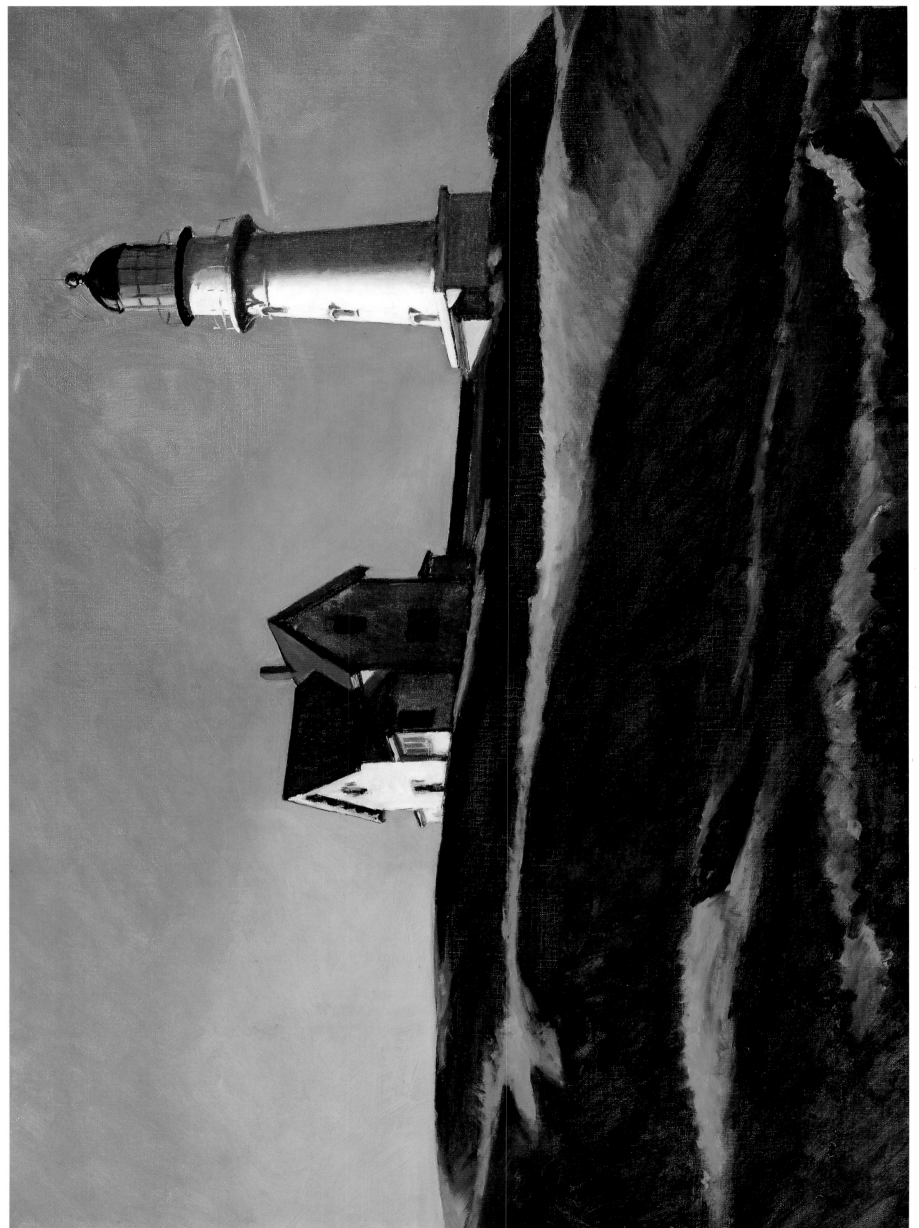

Edward Hopper · Lighthouse Hill

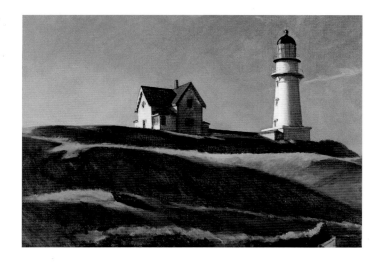

Edward Hopper
Lighthouse Hill, 1927
Hügel mit Leuchtturm
Colline avec phare
Colina con faro
灯台のある丘

Oil on canvas, 73.82 x 102.24 cm
Dallas (TX), Dallas Museum of Art, Gift of Mr. and Mrs. Maurice Purnell

In Hoppers's depictions of lighthouses, the ocean is seldom visible. Yet when we think of lighthouses, we automatically think of the sea; that is, a structure created in an attempt to master nature calls up associations with nature herself.

Wenn Hopper Leuchttürme malt, dann ist meistens das Meer nicht zu sehen. „Leuchtturm" impliziert gerade „Meer": Ein Phänomen, das aus dem Versuch, die Natur zu beherrschen entstanden ist, weist auf die Natur selbst hin.

En général, lorsque Hopper peint des phares, la mer n'apparaît pas dans l'image. « Phare » implique justement « mer » : un phénomène qui est le produit d'une tentative de domination de la nature renvoie lui-même à la nature.

Cuando Hopper pinta por ejemplo faros en la costa, casi nunca se ve el mar. El «faro» implica «mar». Un fenómeno surgido del intento de dominar la naturaleza nos remite nuevamente a ella.

ホッパーが描く灯台の絵では、海が見えることは滅多にない。
それでも私達が灯台を思い浮かべるときには自動的に海も頭に浮かぶ。
それが、自然そのものとのつながりを呼び出す自然を支配する試みの内に作り出された構造なのである。

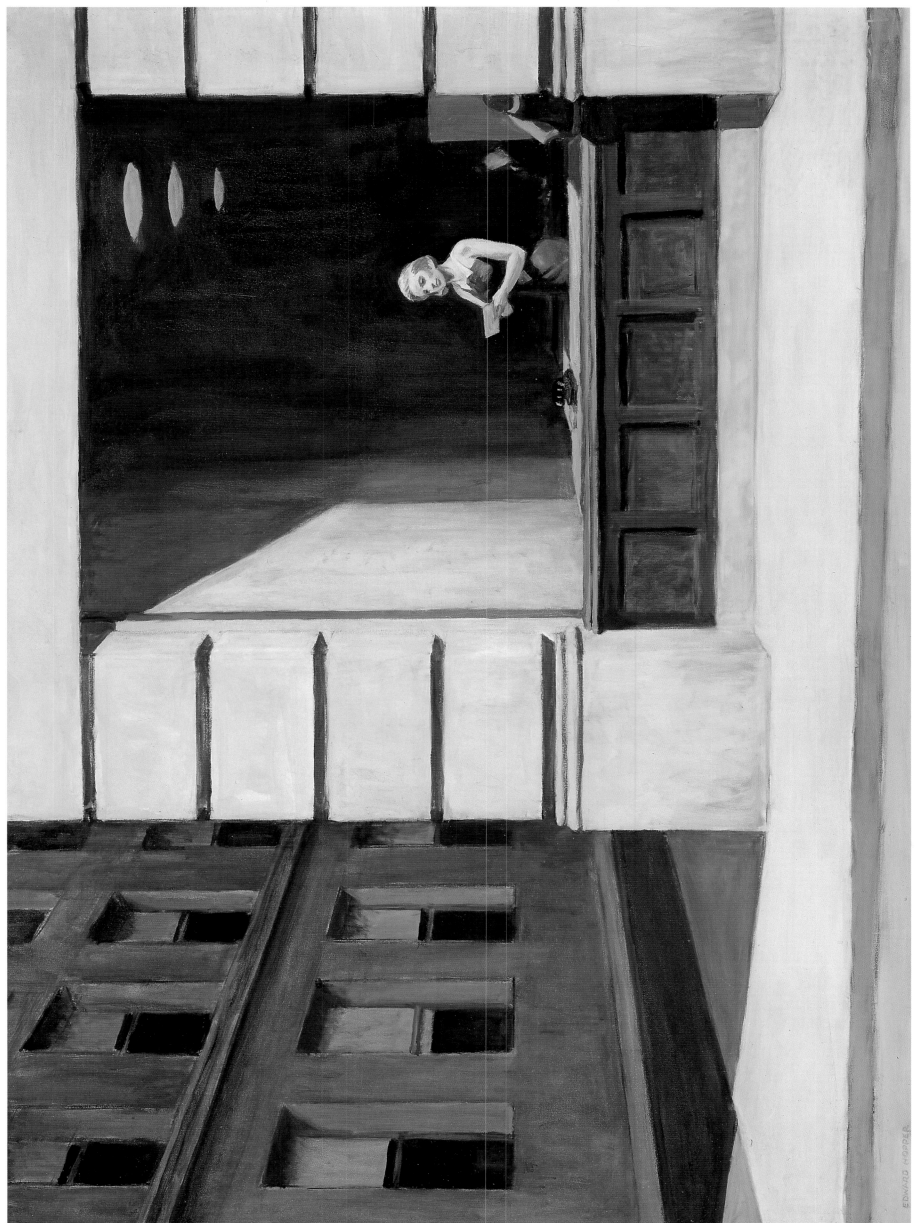

Edward Hopper · *New York Office*

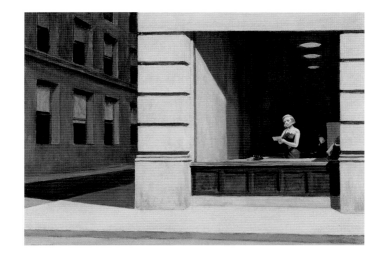

Edward Hopper
New York Office, 1962
Büro in New York
Bureau à New York
Oficina en Nueva York
ニューヨークのオフィス

Oil on canvas, 101.6 x 139.7 cm
Montgomery (AL), Montgomery Museum of Fine Arts, The Blount Collection

Hopper puts us in the voyeur's role in various ways, sometimes including us in the event depicted,
but more often letting us look on from outside.

Hopper macht den Betrachter in verschiedenster Weise zum Voyeur, manchmal bezieht er ihn mit ein,
oft lässt er ihn nur zusehen.

Hopper fait du spectateur un voyeur, et cela de différentes manières ; quelquefois il le fait participer,
souvent il ne le laisse que regarder.

Hopper convierte el observador en *voyeur* de muy diferentes modos: a veces lo «mete» en el cuadro,
a veces se limita a dejarlo ver.

ホッパーはさまざまな状況で私達に窃視者の役割をさせる。
私達は描写される出来事のなかに取り込まれることもあるが、たいていは外からそれを眺めさせられる。

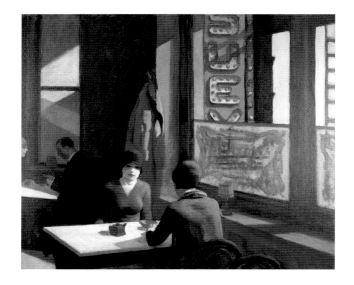

Edward Hopper
Chop Suey, 1929
チョップ・スーイ

Oil on canvas, 81.3 x 96.5 cm
Collection of Mr. and Mrs. Barney A. Ebsworth

The chop suey sign may suggest that the restaurant is in a red-light district: the red of the sign matches the red of the flapper's lipstick; and the lettering of the word on the sign suggests "sex" at first glance.

Das Reklameschild des Chop-Suey-Lokals erinnert an ein Vergnügungsviertel, das grelle Rot des Schildes korrespondiert mit den geschminkten Mündern der Frauen, und die halb verdeckten Buchstaben des Wortes „Suey" lassen den Betrachter wie im Bilderrätsel das Wort „Sex" assoziieren.

L'enseigne publicitaire du restaurant chop-suey évoque un quartierchaud, le rouge criard de l'enseigne correspond aux lèvres maquillées des femmes, et les lettres à moitié cachées du mot « suey » amènent le spectateur à les associer, comme dans un rébus, avec le mot « sexe ».

El anuncio del local Chop Suey recuerda un barrio de diversión; su rojo vivo se corresponde con las bocas pintadas de las mujeres, y las letras medio ocultas de la palabra «Suey» permiten al observador, como en un jeroglífico, la asociación con la palabra «Sex».

チョップ・スーイ食堂の看板は歓楽街を想起させ、看板のけばけばしい赤色は、
女達の紅を塗った唇に照応している。
そして半分隠れた「Suey（スーイ）」のアルファベットは一見して「Sex（セックス）」を連想させる。

Edward Hopper · Second Story Sunlight

Edward Hopper
Second Story Sunlight, 1960
Zweiter Stock im Sonnenlicht
Deuxième étage dans la lumière du soleil
Luz del sol en el segundo piso
二階の日ざし

Oil on canvas, 101.9 x 127.5 cm
New York (NY), Whitney Museum of American Art, purchase,
with funds from the Friends of the Whitney Museum of American Art 60.54

The parallel presentation of human beings and houses gives a certain duality to the work's texture. Such dualities and tensions, forcing a re-assessment of a work's statement, are frequent in Hopper's late work.

Die Verknüpfung der Darstellung von Menschen und Häusern verleiht dem Bild eine doppelte Textur. Im Spätwerk Hoppers werden solche Spannungen, die eine Umwandlung der Bildinhalte inszenieren, häufiger.

La mise en rapport de la représentation de personnes et de maisons confère au tableau une double texture. Dans l'œuvre tardif de Hopper, de telles tensions, qui mettent en scène une métamorphose des contenus picturaux, deviennent plus fréquentes.

El nexo entre la representación de personas y casas proporciona al cuadro una doble textura. En la obra tardía de Hopper se hacen más frecuentes tales tensiones, que revelan una transformación de los contenidos plásticos.

人間と建物の描写を関連づけることで、作品に二重の構造を与える。
否応なしに作品の主張を再考察させるこうした二重性と緊張感は、
ホッパーの晩年の作品に頻繁に見受けられる。

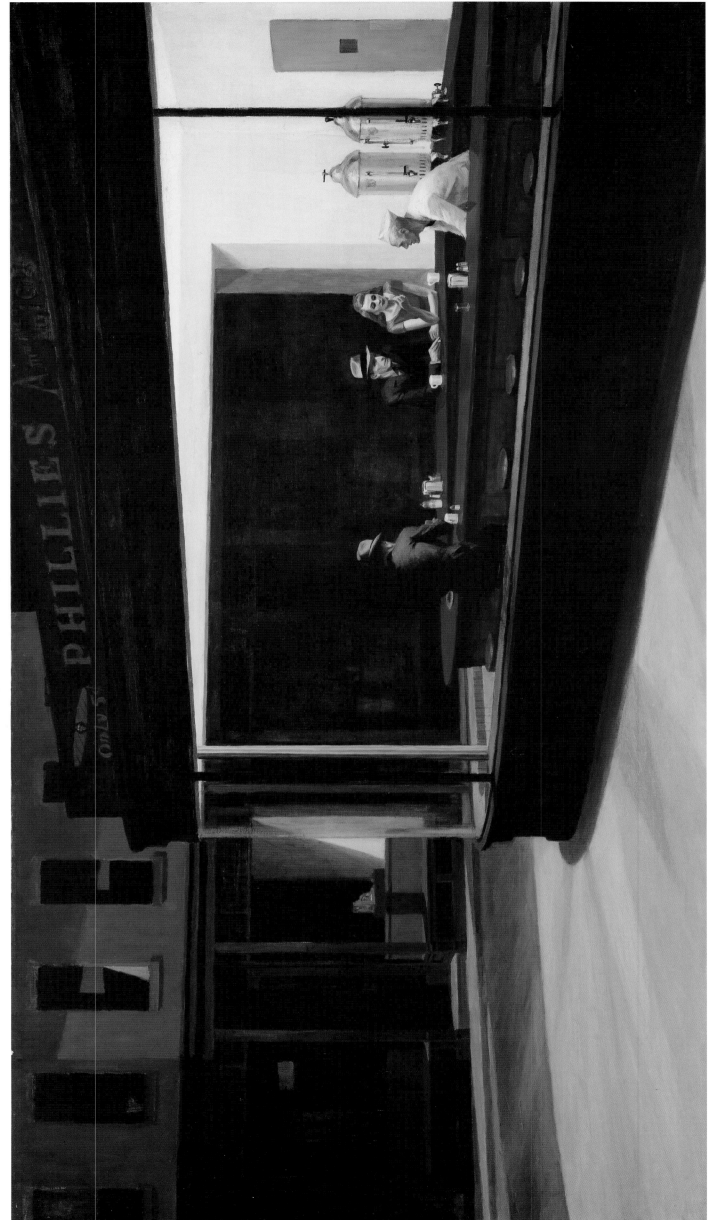

Edward Hopper · Nighthawks

Edward Hopper
Nighthawks, 1942
Nachtschwärmer
Noctambules
Trasnochadores
夜更かしの人々

Oil on canvas, 84.1 x 152.4 cm
Chicago (IL), The Art Institute of Chicago, Friends of American Art Collection, 1942.51

"*Nighthawks* seems to be the way I think of a night street. I didn't see it as particularly lonely. I simplified the scene a great deal and made the restaurant bigger. Unconsciously, probably, I was painting the loneliness of a large city."

„*Nachtschwärmer* zeigt, was ich mir unter einer Straße bei Nacht vorstelle; nicht unbedingt etwas sonderlich Einsames. Ich habe die Szene sehr vereinfacht und das Restaurant vergrößert. Unbewusst wahrscheinlich habe ich die Einsamkeit in einer großen Stadt gemalt."

« *Noctambules* montre comment je m'imagine une rue la nuit; pas nécessairement quelque chose de particulièrement solitaire. J'ai fort simplifié la scène et agrandi le restaurant. Inconsciemment sans doute, j'ai peint la solitude dans une grande ville. »

« *Trasnochadores* muestra lo que me imagino en una calle de noche; no es necesariamente algo particularmente solitario. He simplificado mucho la escena y agrandado el restaurante. Quizá de un modo inconsciente he pintado la soledad en una gran ciudad».

「《夜更かしの人々》は、夜の通りに対する私のイメージを表したものであり、
必ずしも特別な孤独を表したわけではない。私は情景を極めて簡略化し、レストランを引き伸ばした。
無意識ながらおそらく大都会の孤独を描いたのである」

EDWARD HOPPER

Edward Hopper · Sunlight on Brownstones

Edward Hopper
Sunlight on Brownstones, 1956
Sonne auf Brownstones
Soleil sur Brownstones
Sol sobre Brownstones
ブラウンストーンに注ぐ陽光

Oil on canvas, 77.2 x 101.9 cm
Wichita (KS), Wichita Art Museum, The Roland P. Murdock Collection

In Hopper's paintings, atmosphere and mood are rarely evoked by means of facial expression,
but by the physical attitudes of the figures or by the ambience itelf. The human face plays
little role in his depictions.

Ausdruck und Stimmung teilen sich in Hoppers Bildern nie durch eine bestimmte Physiognomie mit,
sie sind hauptsächlich durch das Ambiente oder durch Körperhaltungen bestimmt. Das menschliche
Gesicht spielt bei ihm keine Rolle.

Dans les tableaux de Hopper, l'expression et l'atmosphère ne sont jamais suggérées au moyen d'une
physionomie particulière, elles se définissent surtout par l'ambiance ou l'attitude des figures. Le visage
humain ne joue aucun rôle.

La expresión y el estado de ánimo no vienen dados en los cuadros de Hopper por una fisonomía
determinada, sino por el ambiente o por la postura del cuerpo. E rostro humano no desempeña en
su obra papel alguno.

ホッパーの作品では、空気と雰囲気が顔の表情で想起されることはまれで、
人体の動作や環境そのもので表される。人間の顔にはあまり大した役割を与えない。

Edward Hopper · Cape Cod Evening

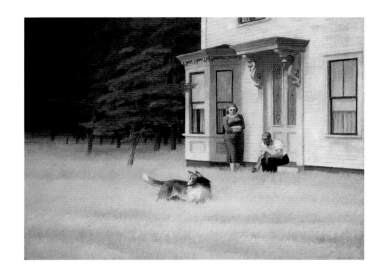

Edward Hopper
Cape Cod Evening, 1939
Abend in Cape Cod
Soir au cap Cod
Atardecer en Cape Cod
コッド岬の夕暮

Oil on canvas, 76.8 x 102.2 cm
Washington (DC), National Gallery of Art, John Hay Whitney Collection

"It is no exact transcription of a place, but pieced together from sketches and
mental impressions of things in the vicinity."

„Das Bild ist keine exakte Übertragung eines realen Ortes, sondern eine Kombination
von Skizzen und Eindrücken von Elementen dieser Gegend."

« Le tableau n'est pas la transposition exacte d'un endroit réel mais une combinaison
d'esquisses et d'impressions fournies par des éléments de cette région. »

«El cuadro no es una transposición exacta de un lugar real, sino una combinación
de bocetos e impresiones de elementos de esa región».

「絵は現実の場所の厳密な転写ではなく、
その地域の諸要素の素描と印象を組み合わせたものである」

EDWARD HOPPER

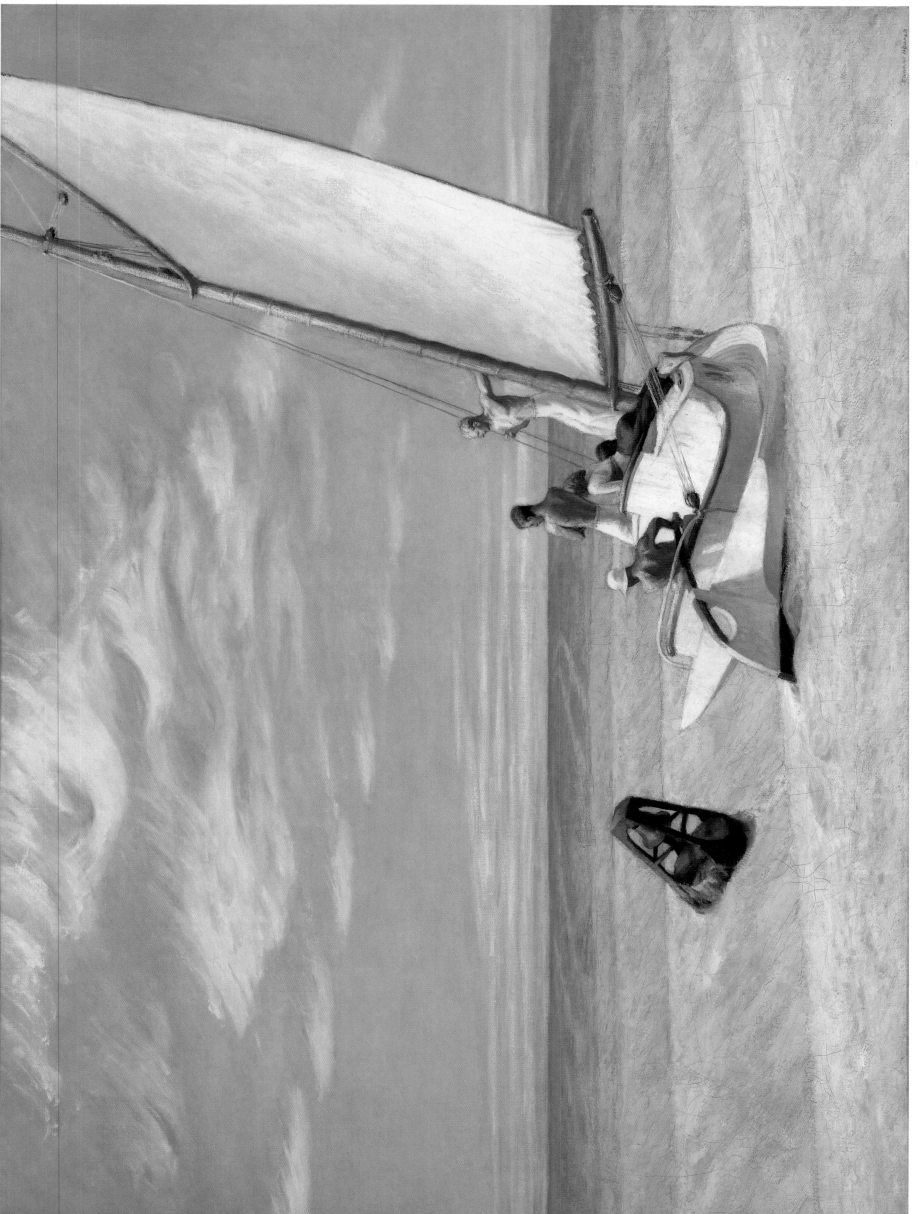

Edward Hopper · Ground Swell

Edward Hopper
Ground Swell, 1939
Dünung
Mer houleuse
Resaca
大きなうねり

Oil on canvas, 92.7 x 127.6 cm
Washington (DC), Corcoran Gallery of Art, The William A. Clarke Fund

"My aim in painting is always, using nature as the medium, to try to project upon canvas
my most intimate reaction to the subject as it appears when I like it most."

„Mein Ziel beim Malen ist immer, die Natur als ein Medium zu benutzen, zu versuchen,
auf die Leinwand meine intimsten Reaktionen auf den Gegenstand zu bannen, so wie er erscheint,
wenn ich ihn am meisten liebe."

« Mon but en peignant est toujours d'utiliser la nature comme un intermédiaire,
de m'efforcer de capter sur la toile mes réactions les plus intimes face à l'objet tel qu'il
apparaît quand je l'aime au plus fort. »

«Cuando pinto, siempre me propongo usar la naturaleza como un medio para intentar captar
en el lienzo mis más íntimas reacciones ante el objeto tal como aparece cuando más me gusta».

「絵画において私がめざしていることは、表現手段として常に自然を用いることである。
私が最も対象を愛したとき、つまり事実が私の興味やあらかじめ想像したものと一致したとき、
その対象のあるがままの姿に対する私の最も内なる反応をキャンバスに投影しようと試みることである」

EDWARD HOPPER

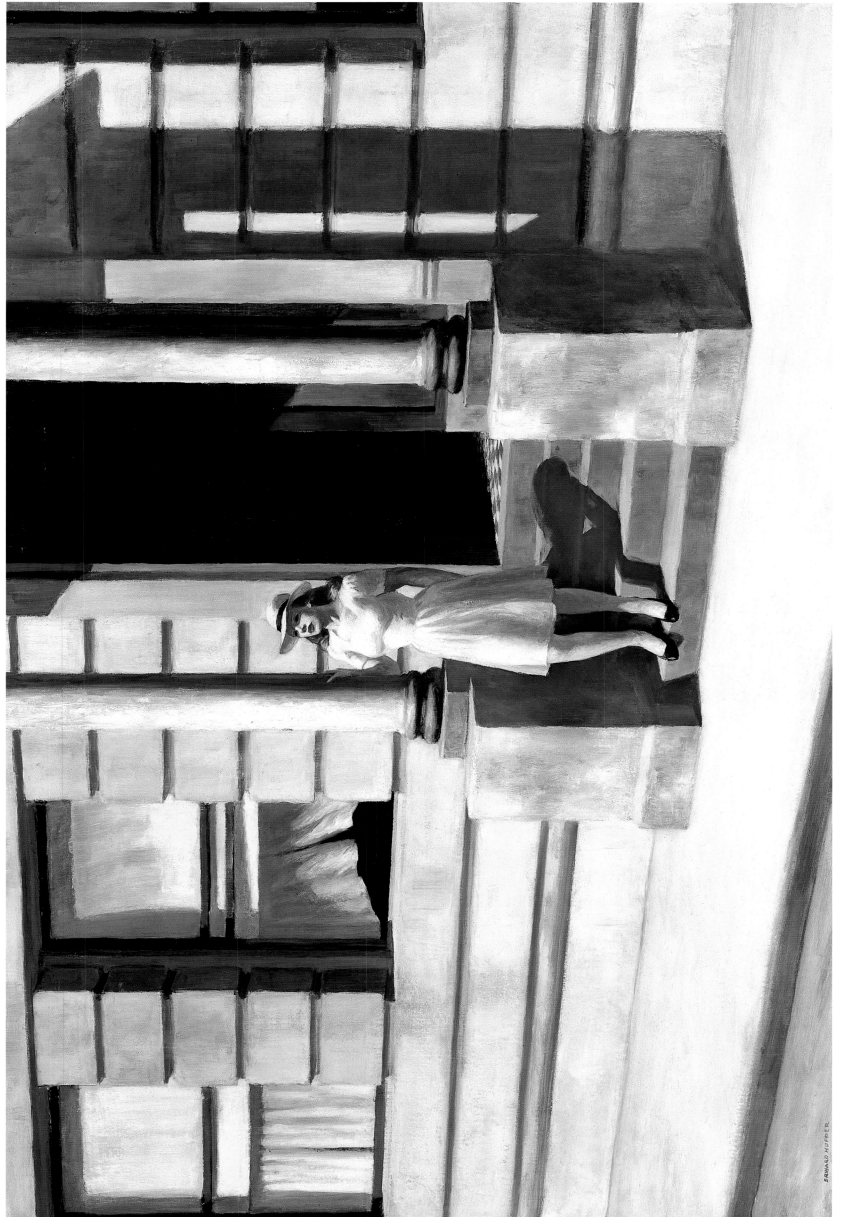

Edward Hopper · Summertime

Edward Hopper
Summertime, 1943
Sommer
Eté
Verano
サマータイム

Oil on canvas, 74 x 111.8 cm
Wilmington (DE), Delaware Art Museum, Gift of Dora Sexton Brown, 1962, 1962–28

"Maybe I am not very human. What I wanted to do was to paint sunlight on the side of a house."

„Vielleicht bin ich nicht sehr menschlich. Mein Anliegen bestand darin,
Sonnenlicht auf einer Hauswand zu malen."

« Peut-être ne suis-je pas très humain. Mon désir consistait à peindre la lumière
du soleil sur le mur d'une maison. »

«Quizá yo no sea muy humano. Mi deseo era pintar la luz del sol sobre una pared».

「もしかしたら私はあまり人間的ではないのかも知れない。
私の関心は、家の壁にあたる陽光をえがくことにある」

EDWARD HOPPER

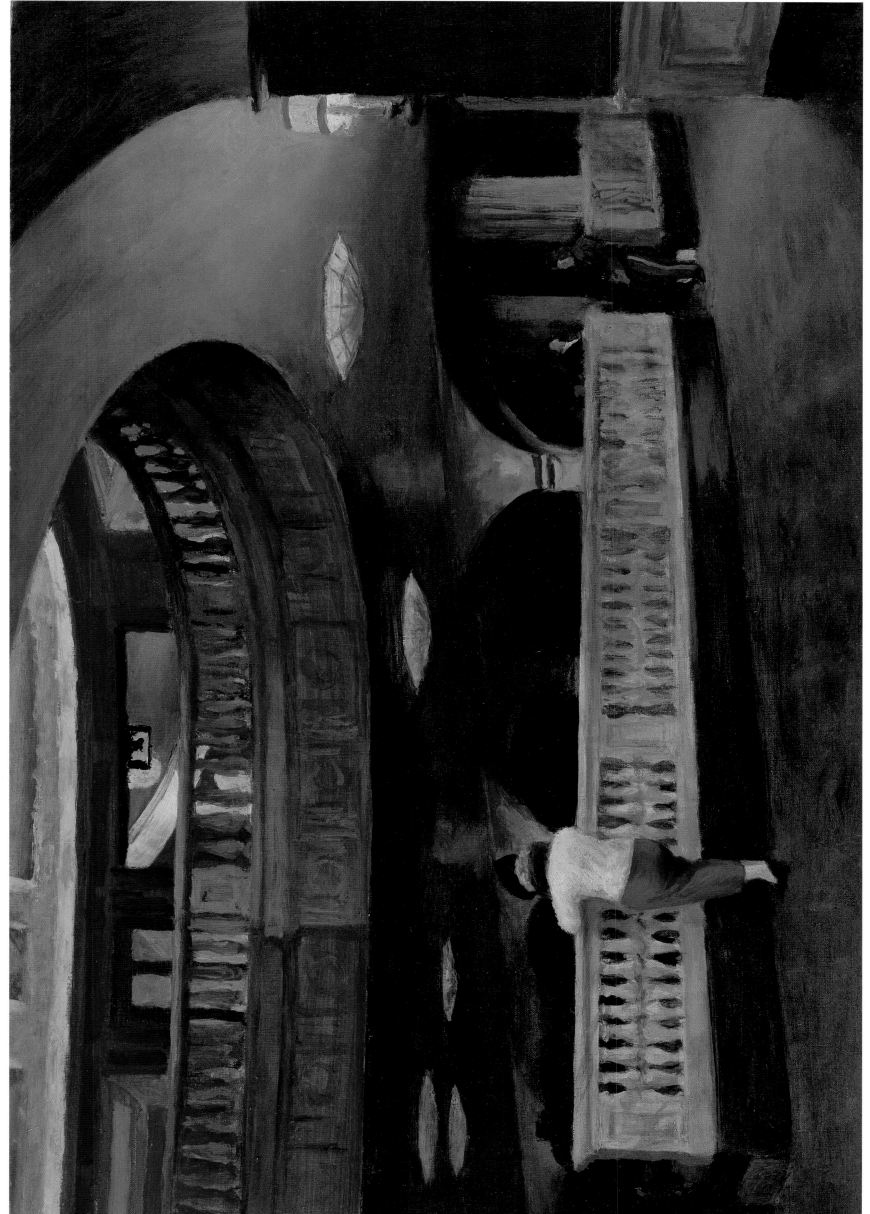

Edward Hopper · The Sheridan Theatre

Edward Hopper
The Sheridan Theatre, 1937
Das Sheridan Theater
Le théâtre Sheridan
El teatro Sheridan
シェリダン劇場

Oil on canvas, 43.5 x 64.1 cm
Newark (NJ), The Newark Museum, Collection of the Newark Museum, 40.118

The metaphor of life as a "theatrum mundi", or universal theatre, is found in many of Hopper's paintings. This holds most obviously for the series of works in which the stage, or movie theatre, actually appear.

Das Gleichnis des „theatrum mundi", des Welttheaters, lässt sich in vielen Bildern Hoppers erkennen. Ein besonderer Komplex sind die Bilder, die sich direkt mit Theater oder auch Kino beschäftigen.

L'allégorie du « theatrum mundi », du théâtre universel, se retrouve dans de nombreux tableaux de Hopper. Il existe un certain nombre de tableaux à part, en relation avec le théâtre ou le cinéma.

El símil del «teatro del mundo» se reconoce en muchos cuadros de Hopper. Un grupo especial lo forman aquellos cuadros que tratan directamente el tema del teatro y el cine.

「テアトルム・ムンディ」あるいは世界劇場はホッパーの作品に多く見られる。
当然ながら、演劇や、または映画館が実際に登場する作品シリーズに一番よく現れている。

Edward Hopper · South Carolina Morning

Edward Hopper
South Carolina Morning, 1955
Morgen in South Carolina
Matin en Caroline du Sud
Mañana en Carolina del Sur
サウス・カロライナの朝

Oil on canvas, 77.6 x 102.2 cm
New York (NY), Whitney Museum of American Art, given in memory of Otto L. Spaeth by his family 67.13

The combination of an open landscape and a house with closed shutters, as well as the woman stepping out the door, show Hopper again addressing his favourite theme, the relationship between interior and exterior world.

Die Kombination der offenen Landschaft mit dem Haus, dessen Fensterläden geschlossen sind, sowie das Heraustreten der Frau von einem Bereich in den anderen nimmt Hoppers Lieblingsthema, das Verhältnis von außen und innen, wieder auf.

Un des thèmes de prédilection de Hopper est le rapport entre extérieur et intérieur. Il le traite à nouveau dans ce tableau sous deux aspects différents: le paysage ouvert contraste avec la maison aux volets clos, la femme sort d'un domaine pour entrer dans l'autre.

La combinación de paisaje abierto y casa con las ventanas cerradas, así como el paso de la mujer de una zona a la otra, recrea el tema favorito de Hopper, la relación entre exterior e interior.

広々とした風景とシャッターの降りた一軒の家、戸口から出ようとする女性の組み合わせで、ホッパーは内部と外部世界の関係という、お気に入りのテーマを再び表現している。

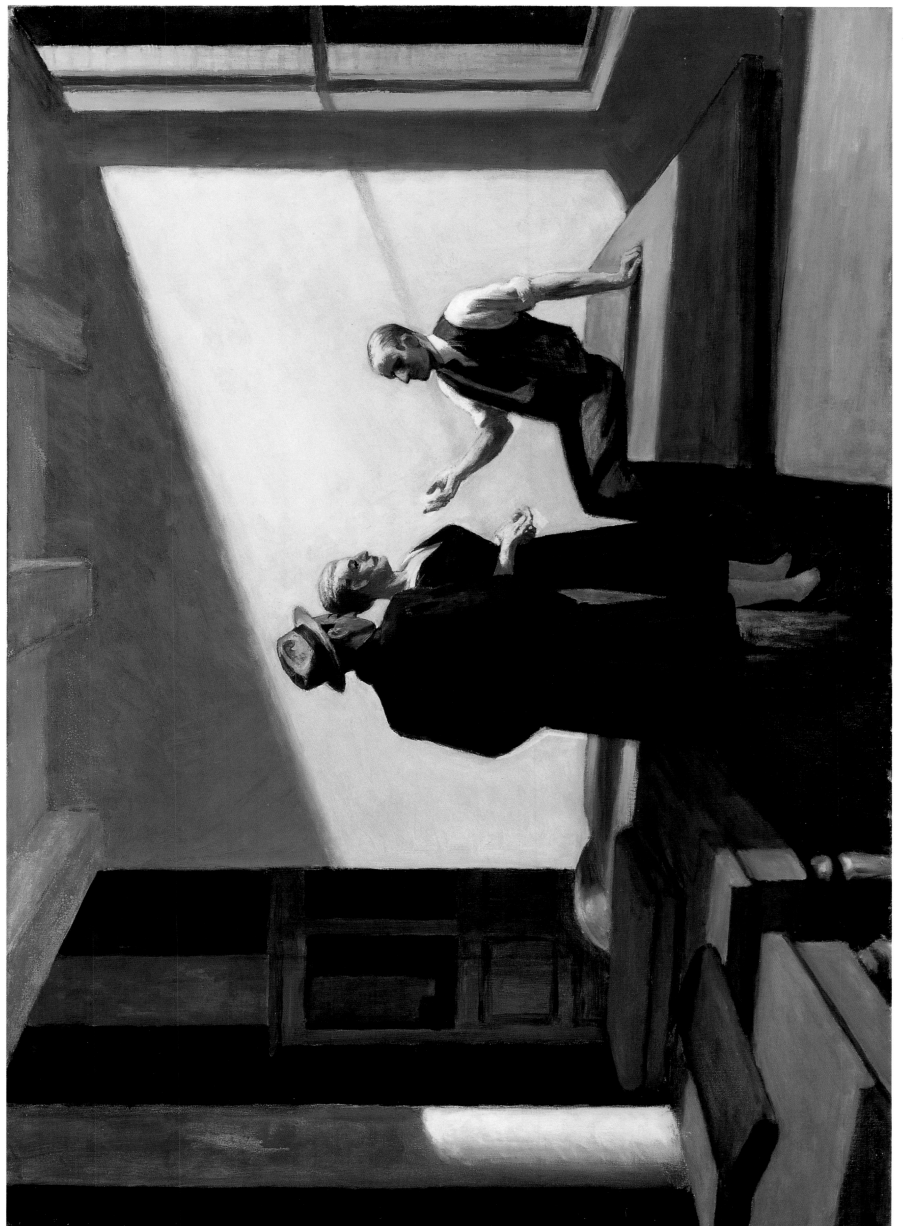

Edward Hopper · Conference at Night

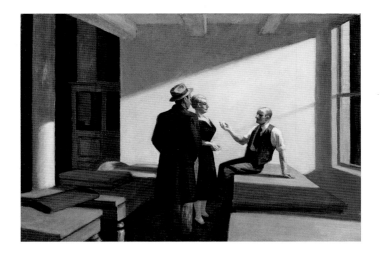

Edward Hopper
Conference at Night, 1949
Nächtliche Unterredung
Conversation nocturne
Conversación nocturna
夜の話し合い

Oil on canvas, 72.1 x 102.6 cm
Wichita (KS), Wichita Art Museum, The Roland P. Murdock Collection

Conference at Night is one of Hopper's few pictures that show people actually talking.
The faces of the three people are wholly impassive, though.

Nächtliche Unterredung ist eines der wenigen Bilder Hoppers, die Menschen in einer
Gesprächssituation zeigen. Doch die Gesichter der Personen in dieser gemalten
Dreiecksgeschichte sind völlig unbewegt.

Conversation nocturne est l'une des rares toiles de Hopper qui montre des gens en train de se parler.
Pourtant, les visages des personnages de cette histoire picturale en triangle sont absolument
immobiles.

Conversación nocturna es uno de los pocos cuadros de Hopper que presentan figuras humanas
conversando. Pero los rostros de las personas en este cuadro sobre un triángulo amoroso están
completamente inmóviles.

《夜の話し合い》はホッパーの作品には珍しく、会話中の人間が示されている。
しかし、ここに描かれた三角関係の人間達の顔はまったく動いていない。

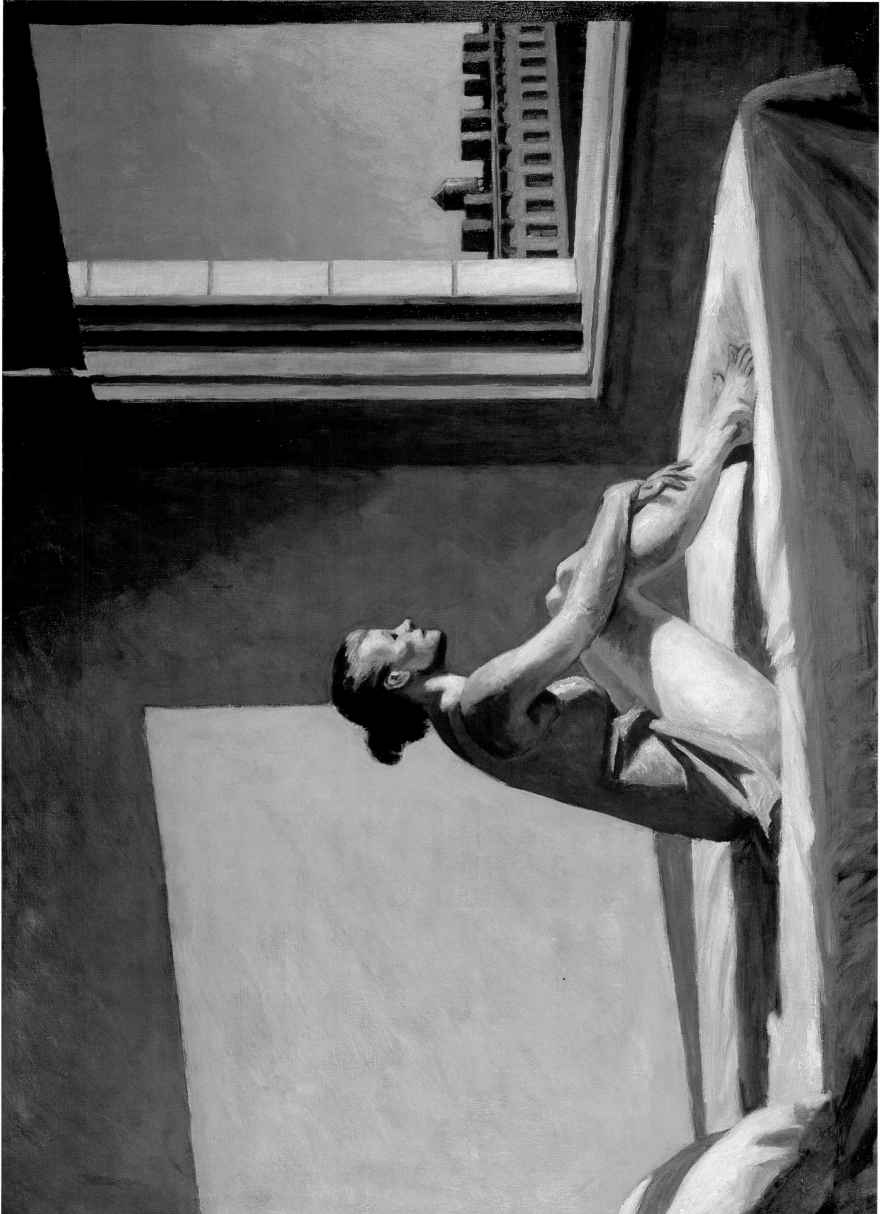

Edward Hopper · Morning Sun

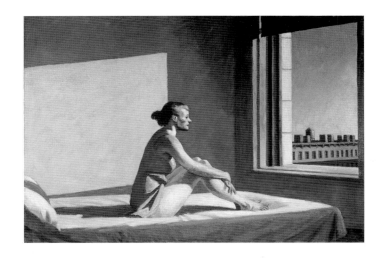

Edward Hopper
Morning Sun, 1952
Morgensonne
Soleil du matin
Sol matutino
朝の日ざし

Oil on canvas, 71.4 x 101.9 cm
Columbus (OH), Columbus Museum of Art, museum purchase: Howald Fund

The room and the woman's body are equally at the mercy of the light. A preliminary study suggests that the picture was originally intended as an exercise in the effects of light on the body.

Der Raumkörper des Zimmers und der Menschenkörper sind gleichermaßen dem Licht ausgesetzt. Eine Vorstudie belegt, dass dieses Bild ursprünglich eine experimentelle Studie über das Licht auf einem Körper sein sollte.

La pièce et le corps humain sont exposés au soleil de la même façon. Une étude préliminaire atteste que ce tableau devait être à l'origine une étude expérimentale de la lumière sur un corps.

El cuerpo espacial de la habitación y el cuerpo humano están igualmente expuestos a la luz. Un boceto demuestra que este cuadro iba a ser originariamente un estudio experimental sobre la luz proyectada sobre un cuerpo.

部屋の空間と人間の肉体は等しく光にさらされている。
1枚の習作が、元来肉体にあたる光を描写するための実験的な作品であったことを裏付けている。

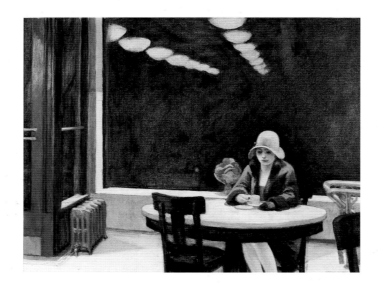

Edward Hopper
Automat, 1927
自動販売機

Oil on canvas, 71.4 x 91.4 cm
Des Moines (IA), Des Moines Art Center, Permanent Collection,
purchased with funds from the Edmundson Art Foundation, 1958.2

The title plainly relates not only to automatic food dispensing but first and foremost to the woman
in the painting herself. Her almost unseeing pose, her alienation and silence, are intensified by the
geometry of the picture and the unoccupied chair.

Offensichtlich bezieht sich der Titel *Automat* nur vordergründig auf das dargestellte Automatenlokal,
vielmehr auf die Frau in seiner Mitte. Ihre fast blicklose Ruhe wird durch die Geometrie des Bildes
und den leeren Stuhl ihr gegenüber noch verstärkt.

Le titre *Automat* ne se rattache manifestement que de manière très générale au restaurant automatique
et bien davantage à la femme qui est assise en son milieu. Sa tranquillité, la quasi-absence de regard,
est encore accentuée par la géométrie du tableau et la chaise vide en face d'elle.

El título *Automat* se refiere sólo en apariencia al local, aludiendo en realidad a la mujer del centro.
Su tranquilidad casi sin mirada es también acentuada por la geometría del cuadro y la silla vacía
junto a ella.

題名は、描き出された自動販売機とは表面上の関係を持つだけで、
それよりはむしろ画面中央の女に関係している。彼女のうつろな落ち着きは、
画面の幾何学と彼女の前に置かれた空の椅子によってさらに強調されている。